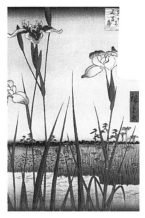

HIROSHIGE
Iris Garden at Horikiri

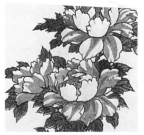

HIROSHIGE II
Peony and Butterfly

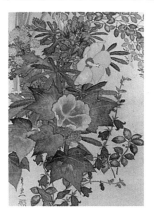

KIITSU
Flowers and Grasses of the
Seasons (detail)

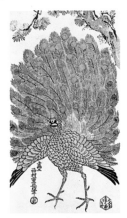

SHIGENAGA
Peacock

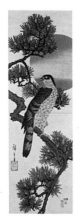

HIROSHIGE
Hawk in a Pine Tree

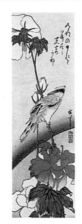

HIROSHIGE
Rose Mallow and Bird

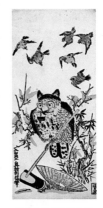

TOSHINOBU
Horned Owl and
Sparrows

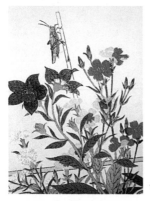

UTAMARO
Balloon-flower with Other Plants,
and a Cicada

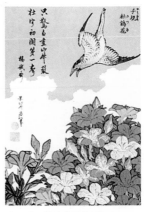

HOKUSAI
Cuckoo and Azalea

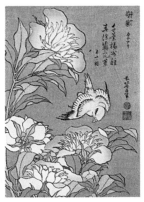

HOKUSAI
Peonies and a Canary

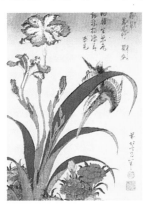

HOKUSAI
Kingfisher, Irises, and Pinks

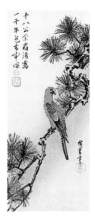

HIROSHIGE
Parrot on a Branch
of Pine

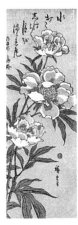

HIROSHIGE
Peonies

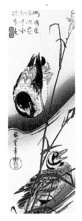

HIROSHIGE
Two Ducks Swimming
Among Reeds

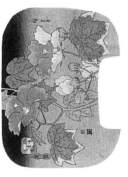

HIROSHIGE / Hibiscus

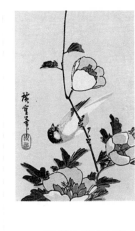

HIROSHIGE / Tit and Peony

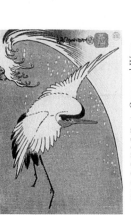

HIROSHIGE / Crane and Wave

HIROSHIGE
Chrysanthemums and a Kakemono Depicting a Full Moon